Ansel

Adams

1902-1984

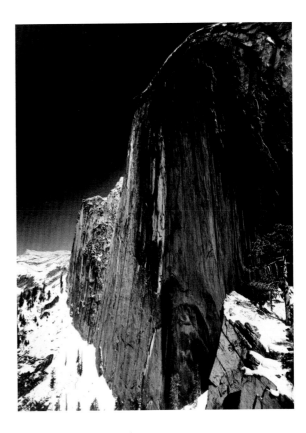

Edited by James Alinder ◆ Untitled 37 ◆ The Friends of Photography

ACKNOWLEDGEMENTS

Every book published presents a unique set of problems. To have them solved in a very short time, as is the case with this book, requires the wonderful cooperation of many individuals. I must first acknowledge the legacy of Ansel Adams. It is his powerful and lasting contribution to our world that is celebrated in this volume. Virginia Adams has been most cooperative and gracious in sharing her memories of her fifty-six years with Ansel. The seven appreciations presented at the May 11 Memorial Celebration are included in this book, and we wholeheartedly thank those authors— Mary Alinder, Peter C. Bunnell, Senator Alan Cranston, The Reverend Alfred Glass, Rosario Mazzeo, Wallace Stegner and William A. Turnage. Their contributions were transcribed from statements offered at that event, with minimal editing as necessary for the printed page. Our thanks is also extended to the four individuals who have contributed additional commentary on specific aspects of Adams' career—Anita Ventura Mozley, Beaumont Newhall, John Szarkowski and Anne Wilkes Tucker.

A number of others have made important contributions to the creation of this volume of

Untitled. First of all, thanks must go to the Ansel Adams Publishing Rights Trust and Little, Brown & Company for permission to reproduce Adams' photographs. For valuable additions to my chronology of the artist's life I would particularly like to thank my wife, Mary, and also acknowledge the previous chronologies of Nancy Newhall and Joseph Shubitowski. For their help in locating the photographs, both those of and by Ansel, thanks go to those at the Adams Studio, particularly Phyllis Donohue, Rod Dresser and Sabrina Herring. I also extend a particular thanks to the several photographers whose photographs of Ansel are reproduced in this volume. While the names of a few of them have become lost over the years, the remainder are given credit by their photographs.

Thanks must also go to David Featherstone, for his fluid editing of the texts; to Peter A. Andersen, for his skillful design of the book; to Julia K. Nelson and John Breeden, for their assistance in preparing the manuscripts; and to Pam Feld, Helen Baker and Valerie Capriola for transcribing the written and spoken statements.

The beautiful reproduction quality achieved by David Gardner and his staff at Gardner/Fulmer Lithograph that

makes this book so handsome is gratefully acknowledged.

Finally, a generous contribution by the Polaroid Corporation, with whom Ansel worked as a consultant beginning in 1949, allowed this book to be produced with the extraordinary quality that is synonymous with the name Ansel Adams. J.A.

ISSN 0163-7916;
ISBN 0-933286-41-4
Library of Congress
Catalogue No. 84-81877

Untitled 37: This volume is the thirty-seventh in a series of publications on serious photography by The Friends of Photography, P.O. Box 500, Carmel, CA 93921. Some previous issues are still available.

Designed by
Peter A. Andersen

INTRODUCTION

Despite his remarkable accomplishments in the advancement of creative photography and in the protection of our environment, it is Ansel Adams the *man* that I choose first to remember. Nancy Newhall wrote a wonderful account of his aura remembering their first meeting in 1938:

> *What an extraordinary, mercurial, multiple being! A lion, when you looked into that ardent countenance—the warm brown eyes brilliant under black lashes and flaring, quizzical brows, eyes set wide and deep under the wide, smooth dome, dimmed only by a few wisps of fine black hair, the broken eagle beak of the nose and the unconquerable chin (no beard in those days). An ape, when you considered the delicate ears forever pricked forward as though to catch the furthest whisper, the short, strong neck sunk into the hunch stance of the heavy-pack-carrying mountaineer, the long arms with the thick wrists and powerful tapering fingers. The whole man was radiant; he was like the sun.* [1]

That sun was blazing until the minute he died. He took no vacations and did not recognize weekends. The word "retire" was anathema. There were always projects to be completed in all the varied fields of his interest, and his accomplishments more than justified his great fame. International recognition did not inflate his ego, rather he understood that his tremendous popularity would allow his message to be heard by far greater numbers of people.

Throughout his life, Ansel Adams played an important role in establishing and supporting organizations that would serve the field of creative photography. In his later years, it was The Friends of Photography that gave him the greatest satisfaction, and to which he devoted much time and energy. Adams was a founder of The Friends in 1967, and served as president and, later, chairman of its Board of Trustees. It was in his role as the guiding spirit of the organization that Ansel's influence was most strongly felt. Adams' commitment to excellence and his support of dynamic programming have much to do with the international leadership position The Friends holds today. It is thus fitting that this issue of *Untitled* be devoted to an appreciation of the man who so greatly changed our understanding of the possibilities of creative photography.

The response to Adams' death on Sunday, April 22, 1984, was overwhelming, with front-page stories appearing in

most national newspapers and major coverage on all network radio and television broadcasts. To those who had been closely associated with Ansel, particularly those on the Monterey Peninsula, the sense of loss was particularly strong. On Thursday of that week, arrangements were finalized for a memorial exhibition to be held at The Friends of Photography Gallery. An exhibition of Marion Post Wolcott's photographs, scheduled to open the following day, had already been hung. I called Marion to ask if she would mind delaying her exhibition, and she was in complete agreement. That set into motion a whirlwind of gallery activity.

By noon on Friday, some fifty of Ansel's photographs had been personally selected by Virginia Adams as her favorites of Ansel's life work, and an overworked staff had installed them in the gallery. Several hundred people, informed primarily by word of mouth, attended the opening that evening, followed by thousands during the next two weeks. A single white candle burned brightly throughout the exhibition, celebrating a spirit that would forever remain with us.

On Friday, May 11, more than 700 of Adams' friends and colleagues filled the theater of the Sunset Cultural Center in Carmel for a celebration of Ansel Adams' life. The event was opened by a statement from Virginia and their children, Michael and Anne. Virginia warmly welcomed the audience, saying, "Do not feel sad when you think of Ansel. He loved the beauty of the land. This is a legacy and a challenge. He said, 'There is a world worth saving for all the people of the future.'"

Appreciations were offered by seven people who knew Ansel well—Mary Alinder, Peter C. Bunnell, Senator Alan Cranston, The Reverend Alfred Glass, Rosario Mazzeo, Wallace Stegner and William A. Turnage—and musical interludes were provided by the Cleveland String Quartet. The seven appreciations from the May 11 Celebration are presented in this book, along with four additional essays by individuals from the photographic community—Anita Ventura Mozley, Beaumont Newhall, John Szarkowski and Anne Wilkes Tucker—who detail specific aspects of Adams' career. In the extended chronology, my goal was to make clear the complexity of Ansel the man, and to suggest the immeasurable depth of his contribution to our world.

James Alinder, *Editor*
The *Untitled* Series

NOTE
1. From an unpublished manuscript by Nancy Newhall.

Portrait by Gerry Sharpe.

IN THE HIGH SIERRA
by Anita Ventura Mozley

Ansel Adams often said that his commitment to photography as an expressive medium began when he saw Paul Strand's negatives in Taos in the spring of *1930*. That experience "profoundly altered," as he put it, his concept of photography, directing him toward the rigorous discipline eventually expressed in the Group f/*64* credo, a discipline that governed the production of the print as well as the negative. However, by *1930*, he had produced images, if not prints, that prefigure Taos in *1930* and Group f/*64* in *1932*. Some of them are included in his *Parmelian Prints of the High Sierras*, a portfolio published in San Francisco in *1927*. Others can be seen in the pages of the *Sierra Club Bulletin*, either in half-tone or photogravure reproduction. One of them, *Monolith, the Face of Half Dome*, of April *17, 1927*, is among his most famous. There are other images from this pre-*1930* period that deserve similar acclaim.

In fact, it was during the decade of the *1920*s, when Ansel Adams was a member of the Sierra Club and joined the club's annual mid-summer Outings, the month-long çamping trips into the Sierra arranged for members, that he increasingly simplified and strengthened his photographic vision. This strengthening went step-by-step with his increasing experience of the simplicity, vitality and grandeur of the Sierra, and of the pure light there that heightens contrast, hardens edges and intensifies skies over the bold forms of the high country. It was in these years that he first attained the clarity and expressive vigor for which we now honor his landscape photographs. I believe, then, that his real school was not Taos, but the High Sierra; all that so splendidly followed was built on that hard-granite base.

To photograph mountains, you must first climb *to* them. In just four years after his first visit to Yosemite, Ansel Adams became an experienced mountaineer, and he first made an appearance in the Sierra Club *Bulletin* as a mountaineer in *1920*, when he was eighteen. In a report published in the *Bulletin*, he announced that in June, *1920*, "Mr. L.L. Stopple and myself blazed a trail from Mount Clark to the Merced Pass Trail in the Illilouette Valley, a distance of about five miles." In their ascent, they followed the canyon wall until they were almost under the peak, then worked their way around the southern shoulder of the mountain and climbed its eastern face. "It is a quite difficult and dangerous climb," Adams reported, "and should be undertaken only by those who understand mountaineer-

ing thoroughly."

In the following year he made a ten-day excursion, during which his party reached the Merced Canyon. From there, he reported in the *Bulletin*, he obtained a "marvelous panorama—all the peaks are in full view—but the most startling feature is the vista of Lake Washburn, over two thousand feet directly below." He also climbed Rodgers Peak. "We were turned back only two hundred feet from the summit by the perpendicular cliffs which guard this approach to the mountain's crest," he wrote. "The views were truly grand and well-repaid all our efforts."

Throughout the decade of the *1920s*, Adams accompanied the Sierra Club's Outings and took trips on his own, making photographs in many regions of the High Sierra: in Kings River Canyon; Pate Valley, with its Indian pictographs; Muir Gorge, the pinnacles at the headwaters of Kings River, Mount Brewer, the Black Kaweah, Mount Ritter, the Minarets, the area around the South Fork of the San Joaquin and Evolution Valley. In *1929*, he led forty or so members of the club to the summit of Mount Banner, one of the Sierra's highest peaks.

By then, Adams was recognized as the preeminent photographer of the Sierra Club. The *Bulletin* announced that he joined the Outings "for that special purpose" of photographing them. He offered portfolios of twenty-five selected prints made on the Outings of 1928, 1929 and 1930 for $30. It is during those years of his acknowledged superiority as a photographer of the high-mountain country that the first glimpse of him at work appears. The report is by Walter L. Huber, an intrepid mountaineer and himself a fine photographer. The party is on Mount Resplendent in the Canadian Rockies; it is summer, 1928. When the group reaches the upper ice-fields, it is divided onto two ropes, each led by a Swiss guide:

"As the way became steeper, every step seemed to unfold new views. Everything near at hand was ice, snow and clouds; above, the blue of the firmament seemed very close ... Up all the icy slopes our photographer friend had uncomplainingly carried his equipment, weighing unspeakable pounds. His only regret was that the pace required to keep up with the climbing parties did not afford opportunities to photograph all the wonders around him. He was with us one moment and then far away seeking a vantage point—only photographers were permitted to leave the rope."

Why did his photographs so particularly elicit admiration and support from Sierra Club members? Many of them had been making photographs in the mountains years before Ansel Adams entered the scene. Joseph N. Le Conte, himself an outstanding mountaineer-photographer, describes Adams' superiority in the *Bulletin's* review of *Parmelian Prints*: "By keeping to a simple and rather austere style, the prints assume a dignity and beauty which is not generally conveyed by photography." Le Conte saw in them something of his own long experience of the mountains, something that had not before been interpreted photographically.

If the High Sierra was Ansel Adams' school, then its mountaineer-photographers were his teachers. They not only taught him mountaineering, but, by their example, how to photograph mountains. Among these men were William E. Colby, leader of Sierra Club Outings since *1901*; Le Conte, who in *1890* had made photographic views of the High Sierra that were long considered the finest ever published in the

BANNER PEAK AND THOUSAND ISLAND LAKE, THE SIERRA NEVADA, CALIFORNIA, 1923.

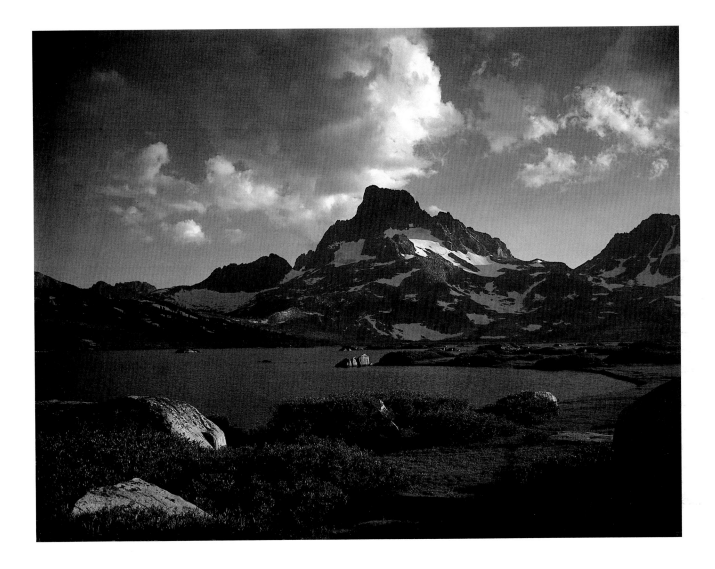

Bulletin; Francis P. Farquhar, historian of the Sierra Nevada; and Walter Huber. For all of them a camera was an essential part of mountaineering gear. "We took several photographs and then at three o'clock began our descent," wrote Farquhar after a hard climb in *1921*. The photographs that Farquhar took on these climbs described what he had seen. While Ansel Adams said in later years that he favored interpretation over appearances, expression over description, he could only come to that because, in the company of men like Farquhar, Le Conte and Huber, he first had to be able to describe. This audience for descriptive photography, I believe, weaned him from the veiled pictorialism he had practised in 1919 on subjects closer to his San Francisco home. It was, after all, required of a person who climbed a mountain and took a photograph that he or she be able to convey the view to people who had not climbed the mountain.

What Adams was able to add, eventually, was what he felt about the view. It is possible to speculate that an early key to that expressive end was a photograph whose purposes were scientifically descriptive. "A very interesting photograph of the Sierra from Mount Hamilton was presented by Dr. R. G. Aitkin, of the Lick Observatory," he noted in his *1921*

report as custodian of Le Conte Memorial Lodge in Yosemite Valley. This panoramic view of the Sierra from the Coast Range was made with infrared plates protected by a ruby filter. But, as W. H. Wright of the Observatory reported in the *Bulletin*, it was not necessary to use troublesome infrared to secure good distance range. Instead, he wrote, "a good commercial panchromatic plate behind a Wrattan A filter (red) gives good atmospheric penetration." Also, one might add, the high contrast it provides is a good ally of emotional charge.

The timing of both public and private events seems to have been right for Adams' involvement in these Yosemite and High Sierra adventures. In *1915*, the year before his first visit to Yosemite, the California Legislature had appropriated $10,000 to build a trail in memory of John Muir, the geologist and naturalist, who had been president of the Sierra Club from its founding in 1892 until his death in 1914. The John Muir Trail would traverse the Sierra, Muir's "Range of Light," close to its highest peaks and passes, from Yosemite Valley south to Mount Whitney. This would create a route for saddle and pack animals, and thus make possible long trips with heavy equipment to the great Sierran peaks. Other trails were also being developed; those in

and about the Tuolumne River Canyon, for instance, which had not before been opened, even to pedestrians. Another route of access to the high country would be the Tioga Road, which was widened and extended eastward by 1920 to reveal a Yosemite few had seen, a land of snow and lakes, glaciers and canyons.

The spirit of John Muir, the man who was described as the great interpreter of the Sierra, who spoke of *mountain sculpture* and *earth gesture* in his writings on the glacial origins of the Sierra, was very much with the Sierra Club in those years. His *Studies in the Sierra* of the early 1870s were being reprinted in the *Bulletin*, and his writings were read around Outing campfires. Adams bought several of Muir's publications for the library of Le Conte Lodge.

During Ansel Adams' early years in Yosemite, the elite group of alpinists who formed the Sierra Club were experiencing new pressures brought by the influx of tourists and the emergencies of the First World War. With Muir, they had fought the battle to save Hetch Hetchy Valley from its present use as the source of San Francisco's water supply; during the war there were other attempts at commercialization of the Sierra's resources made by sheep ranchers and private

power and lumber companies. Members of the Sierra Club were urged to join the battles, to remember John Muir's words on the founding of the club, "do something for wilderness and make the mountains glad."

In 1917, the National Park Service was organized as the ninth bureau of the Department of the Interior. Under its director, Stephen T. Mather, the Service worked closely with the Sierra Club to conserve the wilderness and to protect it for the enjoyment future generations. Ansel Adams found his place in this transitional ferment, not only as a photographer, but as an informed political activist. It was then that he became the protector and conservator, and above all the interpreter, as John Muir had been, of the High Sierra.

As Ansel Adams' mastery of landscape photography accompanied his growing acquaintance with the severity and austerity of the Sierra terrain, his ability to formulate a photographic aesthetic also grew. By 1928, he was able to imply this aesthetic in a review of Geoffrey Winthrop Young's *On High Hills: Memories of the Alps*, published in the *Sierra Club Bulletin* for February, 1929. He admires the author's style in terms that apply also to his considerations of photography. He speaks of the "impeccable, accurate style" of the prose; it is

a style that "indicates intense emotional response to situations of the beautiful and heroic, as well as precise and inclusive observation." Precision and expression: these are the terms of the dialectic he was engaged in as a photographer. Later, he refined his formulation in a specific application to high-mountain photography. In his Foreword to *Sierra Nevada, The John Muir Trail* of 1935, he wrote, "The camera submits a statement of actuality which 'intellectualizes' nature, thereby intensifying potential emotional significances."

Twelve years earlier, Adams had realized that precision and expression in the photograph *Banner Peak and Thousand Island Lake*, made in the Central Sierra in 1932. One of the eighteen photographs published in the *Parmelian* portfolio, *Banner Peak* is also included in *Sierra Nevada*, the book he offered as "my best work with the camera in the Sierra." This early photograph perfectly meets what he calls his program for the latter publication: that "factual, informative qualities be submerged in favor of purely emotional interpretive elements." It is a bellwether of his decision, also stated in *High Sierra*, to confine the tone-scale of his prints "to a vibrant deep register," and to adhere "to a certain austerity throughout,

in accentuating the acuteness of edge and texture, and in stylizing the severity, grandeur and poignant minutiae of the mountains."

In *Banner Peak* we have it all—the controlled dark tonal scale, the simplification of the predominating forms of land, lake and peak within that narrow range. The sobriety of this tight-knit image, taut left to right, top to bottom, is vivified by the bright-lit rocks and the white calligraphy of snow, glorified and completed by the coda-like cloud-banner that is flung from the dark, dominating peak. And this is not so singular an image among those he produced in the High Sierra in the 1920s. As you turn the fine letterpress pages of the *Sierra Club Bulletin* you come to many halftone reproductions that you can recognize (and by his own standards) as photographs by Ansel E. Adams. It is tempting to name them, but the list is long, and the discovery can be made by studying the *Sierra Club Bulletin* of the 1920. The rest, as they say, is history. It is a history whose headwaters lie in the High Sierra.

ANITA VENTURA MOZLEY is the curator of photography at the Stanford University Museum of Art and a former advisory trustee of The Friends of Photography.

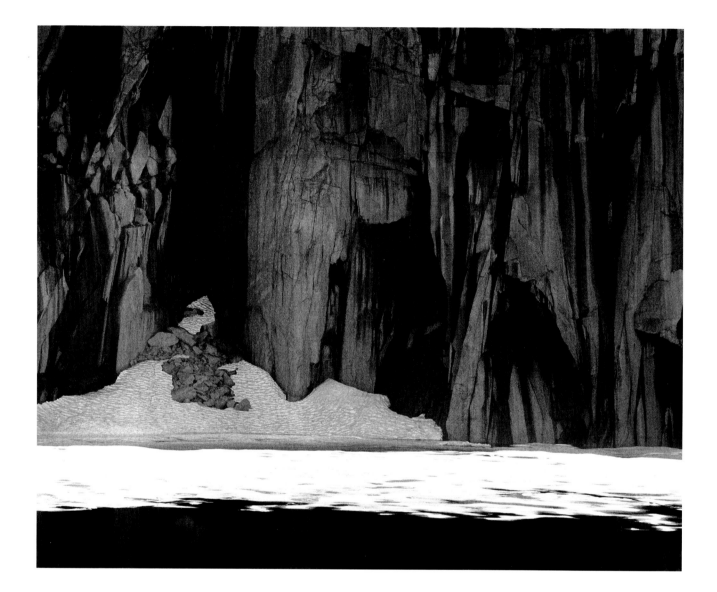

KAWEAH GAP[1] AND ITS VARIANTS
by John Szarkowski

Ferdinand Reyher, writing of Atget in 1948, said that "The basic thing that matters is where a man stands. All the rest is picture making."[2] I think that Ansel Adams understood the truth of this; but out of a native generosity of spirit and dedication to democratic principles, he chose generally not to speak about it. Reyher's rule is uncompromisingly elitist; only the original photographer knows (or rather, finds) the right place to stand, and no art school or textbook will help the others. It is thus kinder and more useful to restrict one's advice to matters of craft, and not rail against the supplicant for having failed to find a subject.

For the student who understands the problem, and is therefore not beyond hope, it might be heartening to know that even the best photographers in their best years do not know in advance where to stand, which is why their brows are perpetually half-knit as they stalk the world in search of meaning that will fill a rectangle. They find, on most days, a little less. This is true of course not only for photographers. Renoir said, "At the start I see my subject in a sort of haze. I know perfectly well that what I shall see in it later is there all the time, but it only becomes apparent after a while."

The five variant negatives that relate to *Kaweah Gap* came to light during the massive proofing of unprinted negatives that was in process during my visit to Carmel in January of 1979. At that time, Adams' recollection of these negatives was hazy, and he was not certain that they were all made on one occasion. It would appear that more of the rubble stones carried by the snow bank (in the upper right corner of Figures 1 and 2) have been exposed by melting in Figure 2. From the angle of the sun it would seem that the time of day was substantially the same for Figures 2 through 5, and that Figure 1 and *Kaweah Gap* were made at a different hour, but perhaps (because of the open water in *Kaweah Gap*) on different days. I would guess from the film edges, partially visible in the proofs, that Figure 1 was made on cut film, and Figures 2 through 5 on film pack. It should be pointed out that the motif of Figures 1 and 2 is contiguous with that of the other four pictures; a close study of the cliff face in the upper left corner of Figure 1 shows that the same area is visible in the upper right corner of Figure 3.

I will assume that we agree that Adams made the right choice; *Kaweah Gap* seems to me not only the best of these six pictures but one of the most

FROZEN LAKE AND CLIFFS, (KAWEAH GAP), SEQUOIA NATIONAL PARK, CALIFORNIA, 1932.

memorable of his career. Nevertheless, the other five negatives are not negligible, and might be brought back as trophies by most excellent photographers. The character of the group is coherent; any of these pictures could serve as inspiration for the stage set of a ballet based on Dante. This is not a landscape for picnics, or for nature appreciation, but for the testing of souls. *Kaweah Gap,* especially, recalls the mood of Arnold Böcklin's *Isle of the Dead* (1880), but is free of the literary romanticism of that remarkable picture. The visual character of Adams' motif also recalls Aaron Siskind's *New York, 1948* (How to Induce Vomiting in Three Languages) and Paul Caponigro's *Sawed Tree Stump,* 1957, both of which are based on similar fascination with violently splintered flat shapes, though neither shares the frigid, deathly elegance of *Kaweah Gap.*

If Adams had not made *Kaweah Gap,* might any of the five variants have achieved a lasting public life? Perhaps the first to be eliminated from consideration would be Figure 3; it has not quite made up its mind whether it wishes to make its point graphically or spacially, and the bottom half of the picture is mushy, not adequately enough articulated to meet Adams' standards. Figure 1 must have looked

wonderful on the groundglass, where the central white shape was radiant and vital; but in the proof it is dead, too large and amorphous to work as a shape. If it could be printed to be satisfactory as a beautiful surface, the solution would probably destroy the idea of a picture made up of the tight interlocking of hard-edged shapes. A lower vantage point, if it had been possible, might have compressed and energized the white shape. The profile of the dying ice god (upper right) is good in itself, but not quite part of a coherent image. The ice god is also good in Figure 2, and better incorporated into the total picture, although the upper right edge and the lower left corner are not clearly resolved, and edge-burning, no matter how judicious, might call attention to the problem rather than solve it. Nevertheless, Figure 2 is an exciting picture, and it would be an adventure to see what kind of finished print it might yield.

Between Figures 4 and 5, the latter seems marginally better to me. The strong pattern created by the cliffs in sunlight in Figure 4 overwhelms the head of the sea serpent (in the deepest recess of the cliff wall), and makes its central placement seem a miscalculation. In Figure 5, the plane of the rock wall is more strongly established, and the recess seems

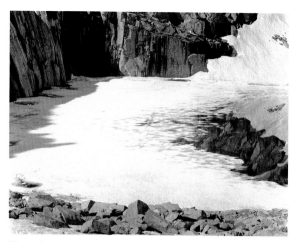

Figure 1.

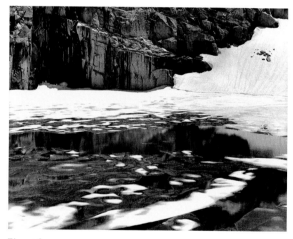

Figure 2.

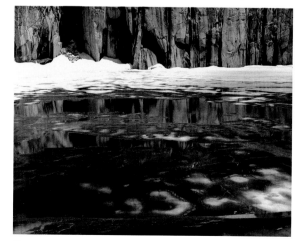

Figure 3.

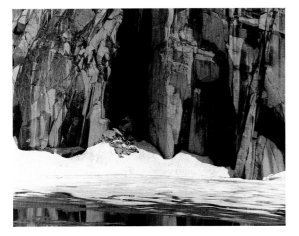

Figure 4.

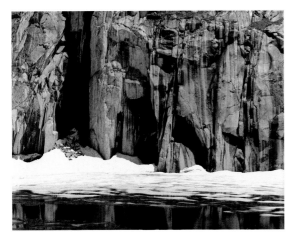

Figure 5.

not to be a hole in the picture plane but a modulation of it.

None of the almost satisfactory variants would be an adequate replacement for *Kaweah Gap*, an astonishing and, it seems to me, unprecedented photograph. But the variants remind us of the difficulty of the art we practise and serve, and of the necessity of achieving and maintaining the passion and the energy, psychic and physical, that might allow us to continue beyond the interesting.

NOTES

1. Although the official title of the picture is now *Frozen Lake and Cliffs, Sierra Nevada, Sequoia National Park, 1932*, I am taking the liberty of using the title by which I have thought of it for some forty-five years, for the convenience of its brevity, and because of its fine Indian sound.
2. The Reyher quote comes from the captions that he wrote for the Atget exhibition held at The Addison Gallery of American Art in 1948. They were published in the fall, 1948 issue of *Photo Notes*, the periodical of The Photo League.
3. Renoir, Jean. *Renoir, My Father* (Boston: Little, Brown & Company, 1962), p. 202.

JOHN SZARKOWSKI, director of the Department of Photography at the Museum of Modern Art in New York City, organized the major 1979 exhibition Ansel Adams and the West.

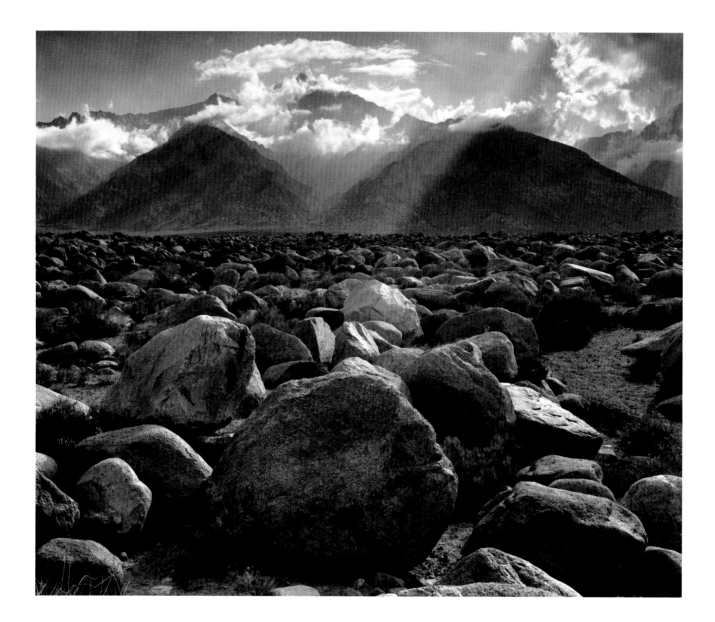

THE LIVELY DEBATE
by Anne Wilkes Tucker

MOUNT WILLIAMSON, THE
SIERRA NEVADA FROM
MANZANAR, CALIFORNIA,
1944.

"Ansel Adams leads with his chin. One member after another takes a swing. He's up. He's down. The crowd roars."[1]

These lines opened a report by photographer Lester Talkington on the lively debate provoked by Ansel Adams when he spoke at the Photo League on November 28, 1948. In the audience were some of the League's most distinguished members, including League president W. Eugene Smith and long-time advisor Paul Strand. Adams was very forthright in stating his views, and he encouraged his audience to react vigorously. The reporter concluded that Adams was a brave man.

The Photo League was a volunteer membership organization of amateur and professional photographers in New York who maintained a headquarters, ran a school, directed exhibitions, published a newsletter and sponsored lectures and symposia. The League's origin in 1936 was generated by radical politics, and its initial energies were fueled by a desire for and belief that photography could effect social change. In 1946, the League began a national membership drive and a capital campaign to become a recognized center for "creative" photography. By 1948, though it was still primarily an organization of documentary photographers, the League had

begun to broaden its goals and programs.

Adams was one of many leading American photographers who supported efforts for a "new" League. He had a deep interest in documentary photography; his book on the loyal Japanese-Americans interned at Manzanar, *Born Free and Equal,* had been published in 1944. While he counted the flowering of the documentary movement in the late thirties and forties as one of the two most significant photographic events of that period,[2] Adams' support was qualified. In his speech, he was open and direct about his reservations. (He also baited his audience, in part for devilment and in part to assure a response.) To a room packed with documentarians and journalists, Adams proposed a new classification system for photography that separated "record," "reportage," and "illustration" from "expressive" photography.[3] He claimed that in reportage, record and illustration, the "motivation comes from without—while expressiveness comes from within."

Eugene Smith and Philippe Halsman were quick to reject any separation of reportage from creative work. Photographing on assignment, they responded, does not prevent reportage from being interpretive or from expressing the photographer's deep per-

sonal feelings. Adams agreed this was possible, but was rarely achieved.

Documentary photography, Adams continued, was often identified with some political expedient, and a conscious determination to document certain subjects made the cameraman a potential propagandist. Too much documentary work, he said, had restricted itself to the negative aspects of society, which made it "only two-dimensional, describing certain conditions and presenting them without real evaluation."

The League's position, on the other hand, was that art which advocated change, and therefore concentrated on conditions that needed changing, was not necessarily limited in its expressive capacities. "An artist is affected by life, by the events of the world around him," argued Strand. "Documentaries have played a big role. But they don't have to be just documentaries. They can also have inner meaning."(Adams himself had said as much in previous writings about the works of Dorothea Lange and other members of the Farm Security Administration. Here one suspects he was enjoying the role of devil's advocate.)

Adams then returned to a point about which he was very serious, and on which he had

Ansel Adams. Photograph by Nancy Newhall.

chided the League before: that too few documentary workers cared about the print as a thing in itself. In 1940, Adams had written to the League his belief that "something perceived—no matter how important in itself, and photographed without a true 'feeling' for the medium—is not conveyed with all the impact it deserved.[4] In his lecture, Adams again commented that lack of technical quality was particularly notable when a strong message was compromised by poor technique.

Adams commented as well on the expression of what he deemed "esoteric" ideas. "The universal quality in a photograph is its emotional appeal to the greatest number of people," he said. "The universal appeal of the print will depend upon the number of people who react to it with the same intensity (the artist felt when making it)." This idea led to considerable discussion on the motivations for making art. Adams felt that group projects like those frequently organized by the Photo League were particularly susceptible for having a limited audience. "You can work out a project here in this room to suit yourselves," he noted, "or you can go outside and find a sponsor who needs your work and will put it to use." "Most organizations are introverted,"

he continued. "The thing to do is go out and raise hell."

These points certainly raised a little hell in the lecture hall. He challenged his audience, and even members who disagreed with nearly everything Adams said agreed that the evening was a success. Discussions continued to break forth far into the night, and these led to a symposium, *Photography As We See It*, with Sid Grossman, Eliot Elisofon, Beaumont Newhall, Jackie Judge and John Morris. Another by-product was the friendly rivalry in an exhibition titled *Two Schools: The Photo League School and the California School of Fine Arts Department of Photography,* which opened in June 1948 and compared the results of Adams' teaching methods with those of the Photo League.

Adams' resignation from the Photo League in 1949 was the result of misunderstandings by both parties that occurred after the 1947 blacklisting of the League by then-Attorney General Tom Clark. During the eight years of his involvement as a member, advisor and provocateur, however, he was a valuable friend of the League, and its members vividly remember his engaging contributions.

NOTES

1. Lester Talkington, "Ansel Adams at the Photo League," *Photo Notes* (March 1948), p. 4. For another report on the evening, see Jacob Deschin, "Reportage Defined: Interpretation, not merely exactness, is desirable," *New York Times,* December 7, 1949.

2. Ansel Adams, "A Decade of Photographic Art," (magazine and date unknown), p. 44. Article reprinted from "Ten Eventful Years," *Encyclopedia Brittanica,* 1947.

3. Adams defined those categories as follows: "1) Record—a simple microfilming and passport photos; 2) Reportage—story assignments conceived by newspaper and magazine editors for photographers to carry out; 3) Illustration—commercial, standard portrait and other fields where pictures are produced to meet the desires or specifications of the client; and 4) Expressive—creative and interpretive photography based on deep thought, feeling and imagination." This and subsequent quotes from that evening appear in the Talkington article cited above.

4. "A Letter from Ansel Adams." *Photo Notes* (June-July, 1940), p. 4.

ANNE WILKES TUCKER is the Gus and Lyndall Wortham Curator of the Museum of Fine Arts, Houston, and is currently writing the first major book on the Photo League.

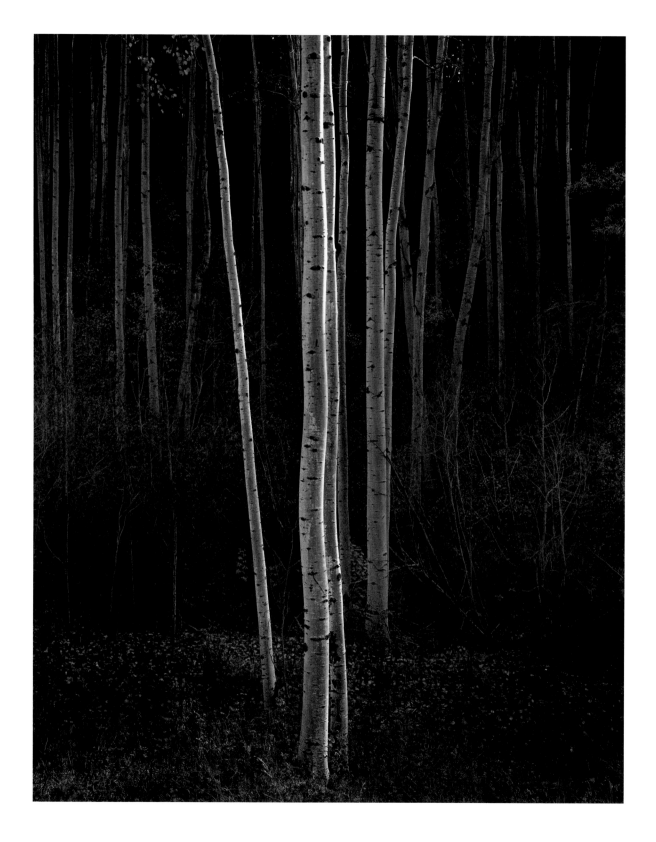

ANSEL ADAMS: FRIEND OF PHOTOGRAPHY
by Beaumont Newhall

As I look back upon forty years of friendship and working companionship with Ansel Adams I am singularly impressed by the great scope of his activity and by his many magnanimous contributions to mankind. His photography alone has already earned him international fame and lasting influence. Beyond that, he was a great teacher who generously shared his prodigious technical skill and knowledge with all who came to seek with sincerity his guidance in his many photographic workshops. His technical manuals, which he constantly updated, have become standard texts, and the many volumes of beautiful photographs, brilliantly reproduced, are both inspiration and aspiration to layman and photographer alike. He showed us how to see with the camera and lens, and how to realize that vision through precise processing of negative and print. As to his lifelong concern with conservation of the land I can, as a layman, speak only with admiration and appreciation for his courageous fight for the preservation of our wilderness heritage.

In addition to these activities, Ansel was a pioneer in the promotion of creative photography as an organizer of exhibitions, and as co-founder of the Department of Photography of The Museum of Modern Art, New York; of the influential quarterly *Aperture* and of The Friends of Photography.

It was my privilege, together with my wife Nancy, to have participated in these highly seminal activities.

In 1933, shortly after he and Willard Van Dyke founded Group f/64, Ansel opened a gallery in downtown San Francisco. He wrote Alfred Stieglitz, "I am planning to operate this gallery as a center for photography." In addition to a program of exhibitions, he gave personal instruction and led group discussions about photography as a creative medium. Unfortunately, the Ansel Adams Gallery was shortlived; he had difficulty in obtaining loans of photographs and furthermore the time was that of the Depression. But his concept of a "center for photography" was not lost.

When his handsome book *Making a Photograph*—a classic too long out of print—was sent to me for review in 1935, I was amazed at his interest in the history of photography. At a time when few photographers knew even the name of the great Scottish photographer David Octavius Hill, he wrote,

"A jewel was formed in the matrix of the early nineteenth century, indigenous to its period and sincere in the

ASPENS, NORTHERN NEW MEXICO, 1958.

purity of its presentation. David Octavius Hill succeeded both in making remarkable photographs and in demonstrating one of the principles of art: complete expression within the limitations of the medium."

Ansel not only appreciated the masterpieces of the past but urged public collection of them.

"Repositories of the most significant photography, past and contemporary, are sorely needed. The understanding of photography as a form of art implies more than a knowledge of physics and chemistry and a superficial education in the aspects of painting and other media. It is necessary to study photography in itself—to interpret the medium in its own terms and within its own limitations."

I agreed completely with this appeal, for I was already dreaming of a museum of photography. Two years later, as a staff member of The Museum of Modern Art in New York, I began organizing a major exhibition, *Photography 1839-1937*. Among the photographers I invited to send work was Ansel, then a stranger to me. Not only did he promptly accept my invitation, but he also suggested that I might like to include an album that he

owned of photographs of the Southwest taken by Timothy H. O'Sullivan in the 1870s. I knew that American photographer's documentation of the Civil War, but nothing of his landscapes. I at once accepted the proffered loan.

Ansel did not see the exhibition when it was originally shown at The Museum of Modern Art in 1937, but he was enthusiastic about the catalogue. This was a hardbound book, elegant in design and in the quality of its ninety-five plates. The text was my first essay on the history of photography as an art medium. Ansel wrote:

I am anxious to compliment you on what looks to be (at a distance, at least) the best show of photography on record.

I was especially interested in your text and feel that it is a major contribution to the literature of photography. With certain slight additions and amendments to augment its already comprehensive qualities (especially in the contemporary section), and the addition of a few more plates, it could be published separately as a work for photographer and layman alike. It is a very fine job. The entire catalogue presents a true "museum" attitude toward the subject.

It is a matter of regret that I cannot see the entire exhibit in New York. But I earnestly hope that it will come out West—and that it will not be reduced in scope or size.

The opportunity of presenting great photographs of the past and present came to Ansel in 1940, when he was invited to direct *A Pageant of Photography* for the Golden Gate International Exposition in San Francisco, held from May 25 to September 29. Nine galleries of the Palace of Fine Arts were placed at his disposal, plus the use of a theater for the screening of motion picture classics. In the short time of six weeks Ansel put together a major exhibition of historical photographs—daguerreotypes by Southworth and Hawes; calotypes by Hill and Adamson; frontier photographs by O'Sullivan, Jackson and Watkins; work of the major Photo-Secessionists; such varied contemporaries as Genthe, Man Ray, Moholy-Nagy, Strand, Lange and Weston; astronomical and other scientific photographs. In addition, he organized seven group exhibitions and seventeen solo exhibitions, each shown for short periods. This record, which any museum curator would be proud of today, was unheard of in 1940! Nancy and I vacationed in

Adams viewing his exhibition, Ansel Adams and the West, *Museum of Modern Art. Photograph by Jim Alinder.*

California that year and visited Ansel and saw the show. We also began talks with Ansel about our hoped-for establishment of a Department of Photography at The Museum of Modern Art. He could not have been more helpful. He put us in touch with his friend David H. McAlpin, who generously lent us his support. With McAlpin's election as a trustee of the museum, the formation of the department was approved. As chairman of the Photography Committee, Dave named Ansel as the vice chairman and invited him to come to New York and work with me for several months. Together we organized the department's inaugural exhibition, *Sixty Photographs,* and *The Civil War and the Frontier,* which introduced for the first time in an art museum the work of Brady's Photographic Corps, Alexander Gardner, O'Sullivan and Jackson. Ansel was my enthusiastic, indefatigable co-curator. I do not know how the department could have materialized so soon without his constant help, encouragement and criticism.

World War II brought an abrupt hiatus to my curatorship when I was commissioned as an Air Force photo-intelligence officer and spent three years overseas. Nancy was appointed acting curator, while Ansel retained his post as vice chair-

man of the committee. On his many trips to New York he worked actively with her and introduced a teaching program in the form of a workshop.

Shortly after I left military service I resigned from the Museum of Modern Art and accepted a position as curator of the newly-founded George Eastman House (now the International Museum of Photography) in Rochester, New York. Ansel again supported me, giving freely of his time to organize a technical display of his Zone System, produce two shows of his own photographs, lecture and contribute to the house organ, *Image.*

Among the honors that I have received, the one I treasure most was quite unexpected and deeply moving. On his seventy-fifth birthday, in 1977, Ansel and Virginia announced their generous endowment to The Museum of Modern Art to create the "Beaumont and Nancy Newhall Curatorial Fellowship in Photography," enabling an intern to work in the photography department for a three-year term. I know that Nancy, had she been alive, would have rejoiced with me in such a generous and practical contribution to photography.

The need for a society of photographers truly dedicated to the ideals, potentials and techniques of creative photography had long been a major

concern of Ansel. He saw no existing organization comparable to the Linked Ring in London and the Photo-Secession in New York at the turn of the century, or even approaching the intensity of the short-lived Group f/64 in San Francisco during the 1930s.

On January 2, 1967, such a society came into being. I quote from my journal entry for that date:

Cole Weston, who is manager of Sunset Center, a former school now converted to a civic cultural center, called a meeting at Ansel's house to discuss the possibility of establishing a Carmel Photography Center. Two good-sized rooms are available in the building.

Besides Ansel, Nancy and myself, there came Rosario Mazzeo, Brett Weston, Morley Baer, Art Connell, Edgar Bissantz, Liliane De Cock, Gerry Sharpe and Gerald Robinson (visiting from Portland, Oregon). Great enthusiasm. Establishment of a society: The Friends of Photography: Ansel, president; Brett, vice president; Edgar, second vice president; Rosario, secretary; Art, treasurer.

I do not need to trace here the outstanding record of The Friends under the leadership of

Ansel, with the support of the distinguished board of trustees, and the energetic work of the staff headed by James Alinder, the executive director. Seventeen years ago I could hardly believe that our little founding group would grow to a membership of more than 12,000, or that I would now be a contributor to the thirty-seventh issue of the society's journal *Untitled*.

Another organization that has benefitted greatly by Ansel's support is the Center for Creative Photography of the University of Arizona at Tucson. He was the first to offer his entire archives to the Center— an example that has been followed by several notable photographers. Ansel's archive not only includes his photographs, his voluminous correspondence and his books, but his negatives as well—under terms that are unique. In 1973 he wrote me of his plan.

If my statement, "The negative is the equivalent of the composer's score; the print is the performance thereof" is so, why not let other photographers "perform" from negative "scores" by other photographers? I think this idea opens PROFOUND possibilities!

For practical financial and professional reasons, we assume that the photographer performs his own scores until

his death. But after his death, why not release his negatives to further performances?

We know that zillions have played the compositions of Chopin, Beethoven, et al., with more competence than the composer ever had. The point is the composer put into the score all the "information", the creative potentials, of his vision. Others may reveal this at a higher level of clarification (in performance) than the composer ever could (the usual situation!)

Hence, my negatives(in the "creative" class)should not be destroyed, but made available (under logical controls) to other photographers to "perform" in any way they wish.This idea is, I think, profoundly potential. I would like your reaction. I would adjust my Will to make negatives available for serious interpretation.

Ansel not only formed a tradition, but with extraordinary foresight he enabled creative artists of the future to build upon his own work, in their own way. Ansel concluded this letter with "Love to Nancy and you (and photography!).

BEAUMONT NEWHALL is professor of the history of photography at the University of New Mexico and a founder of The Friends of Photography.

ANSEL ADAMS
A CHRONOLOGY
by James Alinder

Ansel Easton Adams c.1903.

The Family Home, 129 24th Avenue, San Francisco.

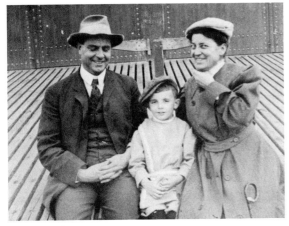

Ansel with his parents.

1902
Born Ansel Easton Adams on February 20, at 114 Maple Street, San Francisco; the only child of Olive Bray and Charles Hitchcock Adams. The family home is completed the next year at 129 24th Avenue, in the sand dune area overlooking the Golden Gate.

1906
Family survives the great San Francisco earthquake, though Ansel falls during an aftershock and breaks his nose.

1907
Grandfather Adams dies and family lumber business fails. Charles Hitchcock Adams spends the rest of his life attempting to repay the debts of the failed business.

1908
An enormously curious and gifted child, he begins a precarious journey through the rigid structure of the school system. Grandfather Bray and Aunt Mary come to live with his family. Father's parents' home "Unadilla" in Atherton, California burns to the ground.

1914
Teaches himself to play the piano and excels at serious music study with Marie Butler.

1915
Despises the regimentation of a regular education, and is taken out of school. For that year's education, his father buys him a season pass to the Panama-Pacific Exposition, which he visits nearly every day. Private tutors later provide continuing education.

1916
Convinces parents to take family vacation in Yosemite National Park. Begins to photograph there using father's box Brownie camera and develops an enthusiastic interest in both photography and the National Park. Returns to Yosemite every year for the rest of his life.

1917
Receives grammar school diploma from the Mrs. Kate M. Wilkins Private School, San Francisco. Though largely self-taught in photography, he works that summer and the next at Frank Dittman's photo-finishing business.

1920
Spends the first of four summers as the custodian of the Sierra Club headquarters in Yosemite. Photography becomes more than a hobby as he begins to articulate his ideas about the creative potentials of the medium. Continues piano studies with professional ambitions, studying with Frederick Zech.

1921

Spends second summer in Yosemite. Finds a piano to practice on at Best's Studio, a Yosemite concession selling paintings, photographs and curios. Meets Harry Best's daughter, Virginia. Takes first high-country trip into the Sierra with Francis Holman and the burro, Mistletoe.

1922

Publishes first article, on the Lyell Fork of the Merced River, in the Sierra Club *Bulletin*.

1924

Explores Kings River Canyon with the Le Conte family. Takes a similar trip the following summer.

1925

Decides to become a concert pianist and purchases a Mason and Hamlin grand piano, the finest available.

1926

Takes first trip to Carmel with Albert Bender, who became his first patron; meets Robinson Jeffers there.

1927

Makes the photograph *Monolith, the Face of Half Dome.* He considers this image to be his first "visualization," using the term to describe the photographer's pre-exposure determination of the visual and emotional qualities of the finished print. Publishes initial portfolio, *Parmelian Prints of the High Sierras* [sic]. Goes on first Sierra Club outing. Travels with Bender in California and New Mexico, meets Mary Austin, Witter Bynner and others.

1928

Marries Virginia Best in Yosemite. First one-man exhibition held at the Sierra Club, San Francisco. His photographs will be included in more than five hundred exhibitions during his lifetime.

1929

Photographs in the Taos Pueblo in northern New Mexico for a book project. In Taos, meets George O'Keeffe and John Marin at Mabel Dodge Luhan's estate. In Yosemite, writes words and music, and acts a leading role for The Bracebridge Dinner, a Christmas production that becomes an annual event.

1930

Meets Paul Strand in Taos, becomes committed to a full-time career in photography after understanding Strand's total dedication to creative photography and seeing his negatives. Builds home and studio at 131 24th Avenue, San Francisco, adjoining parents' home. Publishes *Taos Pueblo*, containing twelve original photographs with text by Mary

Virginia cuts the wedding cake, January 2, 1928.

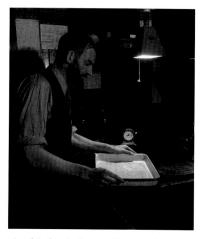

Ansel in his darkroom. Photograph by Virginia Adams.

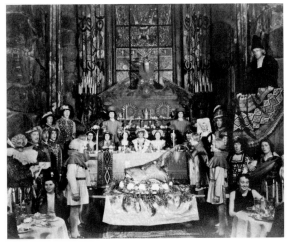

The Bracebridge Dinner, Yosemite.

Ansel at the piano.

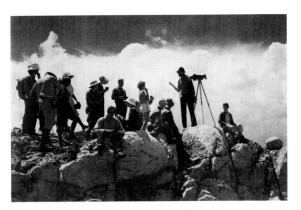

"The Sermon on the Mount". Photograph by Cedric Wright.

Austin. Begins accepting commercial photography assignments, one of the first being catalogue pictures for Gump's, the unique San Francisco specialty store. Continues commercial work into the early 1970s.

1931
Begins writing photography column for *The Fortnightly;* reviews Eugene Atget and Edward Weston exhibitions at San Francisco's M. H. de Young Memorial Museum. Exhibition of sixty prints at the Smithsonian Institute.

1932
Founding member of Group f/64, and is a part of the renowned Group f/64 exhibition at the de Young; also has one-man show there. Makes the photograph *Frozen Lake & Cliffs.*

1933
Son Michael born. Meets Alfred Stieglitz at his gallery An American Place in New York City. Opens Ansel Adams Gallery at 166 Geary Street, San Francisco after return. First New York City exhibition at Delphic Studio.

1934
Begins publishing a series of technical articles, "An Exhibition of my Photographic Technique," in *Camera Craft.*

Writes a coherent thesis of his aesthetic beliefs, "The New Photography," *Modern Photography 1934-35* (London and New York: The Studio Publications). Elected to the Board of Directors of the Sierra Club.

1935
Daughter Anne born. Publishes technical book, *Making a Photograph; An Introduction to Photography* (London & New York: The Studio). First publication of his "Personal Credo" in *Camera Craft.* Teaches in Art Students League Workshop in San Francisco.

1936
One-man exhibition at An American Place. Lobbies Congressmen in Washington, D.C. on behalf of the Sierra Club for the establishment of Kings Canyon National Park. Moves to Berkeley, where he and Virginia live for several months in a Bernard Maybeck-designed home. Virginia inherits Best's Studio after her father's death.

1937
They move to Yosemite in the spring, where they take over the proprietorship of Best's Studio. He continues to work and maintain his professional studio in San Francisco. Takes photography treks with Edward Weston through the High Sierra and with Georgia O'Keeffe and David McAlpin

through the Southwest. Photographs included in first photography exhibition at the Museum of Modern Art, New York City.

1938
Takes O'Keeffe and McAlpin through Yosemite and on High Sierra explorations. Photographs with Edward Weston in the Owens Valley. Publishes *Sierra Nevada: The John Muir Trail* (Berkeley: Archetype Press).

1939
Meets Beaumont and Nancy Newhall in New York. Has major exhibition at the San Francisco Museum of Art.

1940
Teaches first workshop, the U.S. Camera Photographic Forum in Yosemite with Edward Weston. Organizes the exhibition and edits the catalogue for *The Pageant of Photography* held at the Palace of Fine Arts, San Francisco. Helps to found the Department of Photography at the Museum of Modern Art, New York, with Newhall and McAlpin.

1941
Develops his Zone System technique of exposure and development control while teaching at Art Center School in Los Angeles. Begins a photographic mural for the Department of the Interior, but project is cancelled due to world events in 1942. Makes his best-known photograph, *Moonrise, Hernandez, New Mexico* on October 31 at 4:05 P.M. Publishes *Michael and Anne in Yosemite Valley*, text by Virginia Adams (New York: Studio Publications).

1943
Photographs at Manzanar Relocation Center, begins *Born Free and Equal* photo-essay on the loyal Japanese-Americans interned there.

1944
Makes the photographs *Clearing Winter Storm, Mt. Williamson* and *Winter Sunrise*. Paul Strand visits in Yosemite. Publishes *Born Free and Equal* (New York: U.S. Camera).

1946
Receives John Solomon Guggenheim Memorial Foundation Fellowship to photograph the National Parks and Monuments. Founds Department of Photography at the California School of Fine Arts in San Francisco, later renamed the San Francisco Art Institute. Hires Minor White to teach with him. Publishes *Illustrated Guide to Yosemite Valley*, with Virginia Adams (San Francisco: H.S. Crocker).

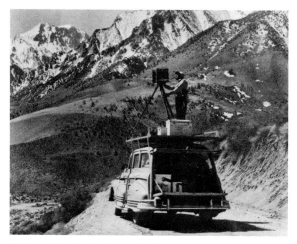

Photographing in the Sierra Nevada. Photograph by Cedric Wright.

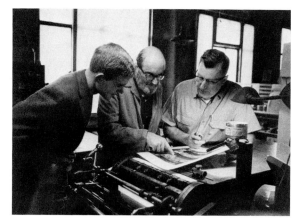

A printing check at Walter Mann's, San Francisco. Photograph by Margot Weiss.

Making the photograph White Branches,
Mono Lake.

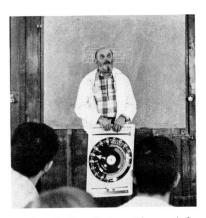

*Teaching the Zone System with a musical
analogy. Photograph by Margot Weiss.*

1947

Does extensive photography in
the National Parks, first photo-
graphic trips to Alaska and
Hawaii. Makes the photograph
White Branches, Mono Lake.

1948

Guggenheim Fellowship re-
newed. Makes the photographs
*Mt. McKinley and Wonder Lake;
Sand Dune, Sunrise* and *Tenaya
Creek, Dogwood, Rain.* Begins
life-long friendship with Dr.
Edwin Land. Sierra Club pub-
lishes *Portfolio I,* with twelve
Adams photographs. Publishes
Basic Photo Series 1: *Camera
and Lens* and 2: *The Negative*
(New York: Morgan & Morgan)
and *Yosemite and the High
Sierra,* edited by Charlotte
E. Mauk with the selected
words of John Muir (Boston:
Houghton Mifflin).

1949

Becomes consultant for newly
founded Polaroid Corporation.

1950

Sierra Club publishes *Portfolio
II, The National Parks & Monu-
ments.* Publishes Basic Photo
Series 3: *The Print* (Morgan &
Morgan), *My Camera in Yosemite
Valley* (Yosemite: V. Adams and
Boston: Houghton Mifflin), *My
Camera in the National Parks*
(Yosemite: V. Adams and
Boston: Houghton Mifflin) and
a reprint of the 1903 title, with
his photographs, *The Land of*
Little Rain, text by Mary Austin
(Boston: Houghton Mifflin).
His mother, Olive, dies.

1951

His father, Charles, dies. Hires
Pirkle Jones as his photographic
assistant through 1953.

1952

Publishes Basic Photo Series 4,
Natural-Light Photography (Mor-
gan & Morgan). Exhibi-
tion at the George Eastman
House, Rochester. Helps
found *Aperture,* a journal of
creative photography, with
the Newhalls, Minor White
and others.

1953

Does *LIFE* photo-essay with
Dorothea Lange on the Mor-
mons in Utah.

1954

Publishes *Death Valley* (Palo
Alto: 5 Associates), *Mission San
Xavier del Bac* (5 Associates) and
*The Pageant of History in Northern
California* (San Francisco: Amer-
ican Trust Co.). Nancy Newhall
contributes the text for all
three books.

1955

The Ansel Adams Yosemite
Workshop, an intense short
term creative photography
learning experience, begins as
an annual event.

1956

Organizes with Nancy Newhall the exhibition *This is the American Earth* for circulation by the United States Information Service (USIS). Publishes Basic Photo Series 5: *Artificial-Light Photography* (Morgan & Morgan). Don Worth becomes a photographic assistant through 1960, and Gerry Sharpe works on special projects through the early 1960s.

1957

Begins producing small, unsigned *Special Edition Prints* of a number of his Yosemite photographs, printed by assistants and for sale only at Best's Studio as a quality souvenir of the park. Film *Ansel Adams, Photographer* produced by Larry Dawson and directed by David Meyers; script by Nancy Newhall, narrated by Beaumont Newhall.

1958

Receives third Guggenheim Fellowship. Makes the photographs *Aspens, Northern New Mexico* in both horizontal and vertical formats. Publishes *The Islands of Hawaii*, text by Edward Joesting (Honolulu: Bishop National Bank of Hawaii). Presented Brehm Memorial Award for distinguished contributions to photography by the Rochester Institute of Technology.

1959

Publishes *Yosemite Valley*, edited by Nancy Newhall (5 Associates). Moderates a series of five films for television, *Photography, the Incisive Art*, directed by Robert Katz.

1960

Sierra Club publishes *Portfolio II, Yosemite Valley*. Makes the photograph *Moon and Half Dome*. Publishes *This is the American Earth*, text by Nancy Newhall (Sierra Club).

1961

Receives honorary Doctor of Fine Arts degree from the University of California, Berkeley.

1962

Builds a home and studio, designed by E. T. Spenser, overlooking the Pacific Ocean in Carmel Highlands, California. Over the next two decades, he produces in the spacious darkroom most of the fine prints made during his career. Publishes *Death Valley and the Creek Called Furnace*, text by Edwin Corle (Los Angeles: Ward Ritchie) and *These We Inherit; The Parklands of America* (Sierra Club).

1963

The Eloquent Light, a retrospective exhibition with prints from 1923 to 1963, shown at the de Young Museum. Receives John

Muir award. Sierra Club publishes *Portfolio IV, What Majestic Word*. Publishes *Polaroid Land Photography Manual* (Morgan & Morgan) and first volume of a biography *Ansel Adams: Volume 1, The Eloquent Light*, text by Nancy Newhall (Sierra Club). Subsequent volumes were not completed. Publishes revised edition of *Illustrated Guide to Yosemite Valley* (Sierra Club). Liliane de Cock becomes photographic assistant through 1971. Begins annual New Year's Day open house for their friends.

1964

Publishes *An Introduction to Hawaii*, text by Edward Joesting (5 Associates).

1965

Takes active role in President Johnson's environmental task force, photographs published in the President's report, *A More Beautiful America . . .* (New York: American Conservation Association). Major exhibition *Ansel Adams: The Redwood Empire* held at the San Francisco Museum of Modern Art, circulated a decade later by the California Historical Society.

1966

Elected a fellow of the American Academy of Arts and Sciences.

1967

Founder, President and, later, Chairman of the Board of

At the opening of The Friends of Photography's initial exhibition. Photograph by Peter Stackpole.

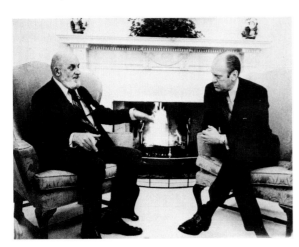

Lobbying President Ford. White House photograph by Ricardo Thomas.

Trustees, of The Friends of Photography, Carmel. Receives honorary Doctor of Humanities degree from Occidental College. Publishes *Fiat Lux: The University of California,* text by Nancy Newhall (New York: McGraw Hill).

1968
Makes the photograph *El Capitan, Winter Sunrise.* Receives Conservation Service Award from the US Department of Interior.

1969
Delivers Alfred Stieglitz Memorial Lecture at Princeton University. Receives Progress Medal from the Photographic Society of America.

1970
Receives Chubb Fellowship from Yale University. Publishes *The Tetons and the Yellowstone,* text by Nancy Newhall (5 Associates) and revised edition of Basic Photo Series (Morgan & Morgan).

1971
Parasol Press publishes *Portfolio V,* with ten prints. William A. Turnage hired as manager of Ansel Adams Gallery, eventually becomes his full-time business manager until 1977.

1972
Exhibits retrospective *Recollected Moments,* at San Francisco

Museum of Modern Art; show is traveled by USIS to Europe and South America. Publishes a monograph *Ansel Adams,* edited by Liliane De Cock (Morgan & Morgan). Best's Studio is renamed the Ansel Adams Gallery. Ted Orland becomes photographic assistant until 1974.

1973
Two exhibitions of Adams photographs organized and circulated by The Friends of Photography.

1974
First trip to Europe, where he teaches at the Arles, France photography festival. Major exhibition *Photographs by Ansel Adams* initiated and circulated by the Metropolitan Museum of Art, later travels to Europe and Russia, through 1977. Receives honorary Doctor of Fine Arts degree from the University of Massachusetts at Amherst. Parasol Press publishes *Portfolio VI,* with ten prints. Begins exclusive publishing agreement with the New York Graphic Society, a division of Little, Brown and Company. Publishes *Singular Images* (Dobbs Ferry, New York: Morgan & Morgan) and *Images 1923-1974* (Boston: New York Graphic Society [NYGS].) Andrea Gray becomes executive assistant

until 1980, and Alan Ross becomes photographic assistant until 1979.

1975
Stops taking individual print orders at the end of the year, but the 3,000 photographs ordered by December 31 take three years to print. Helps found the Center for Creative Photography at the University of Arizona, Tucson, where his archive is established. Receives honorary Doctor of Fine Arts degree from the University.

1976
Parasol Press publishes *Portfolio VII*, with twelve images. Meets President Ford at the White House to discuss environmental policy. Returns to Arles Photography Festival during second European trip and photographs in Scotland, Switzerland and France. Elected Honorary Fellow of the Royal Photographic Society of Great Britain. Publishes *The Portfolios of Ansel Adams* (NYGS) and *Photographs of the Southwest*, text by Lawrence Clark Powell (NYGS). Lectures in London, Tucson, Los Angeles and San Diego. Major exhibition at the Victoria and Albert Museum, London.

1977
Publishes facsimile reprint of the book *Taos Pueblo* (NYGS). Endows curatorial fellowship at the Museum of Modern Art in

honor of Beaumont and Nancy Newhall. Exhibition *Photographs of the Southwest 1928-1968*, organized and circulated by the Center for Creative Photography. Begins complete revision of his technical books with the collaboration of Robert Baker.

1978
Publishes *Ansel Adams: 50 Years of Portraits*, by James Alinder (Carmel: The Friends of Photography). Publishes *Polaroid Land Photography* (NYGS). Elected Honorary Vice President of the Sierra Club. Selected as an honorary member of the Moscow Committee of Graphic Artists, Photography Section.

1979
Subject of *Time* magazine cover story. Dramatic increase in sales of Adams prints in public auctions and through photography dealers, leading to a significant expansion of interest in collecting fine art photography. Adams prints account for some half of the total dollar value of photography sales during the year. Major retrospective exhibition *Ansel Adams and the West* held at the Museum of Modern Art. Publishes *Yosemite and the Range of Light* (NYGS), eventual sales total over 100,000 copies. Founding member and vice president of the Board of Trustees, The Big Sur Foundation. Lectures in Carmel, New York, San Fran-

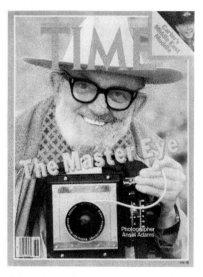

Time, September 3, 1979. Photograph by David Kennerly.

Teaching the Yosemite Workshop. Photograph by Jim Alinder.

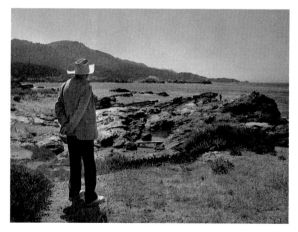

At Point Lobos, 1983. Photograph by Jim Alinder.

cisco, Boston, Detroit, Cleveland and Minneapolis. Begins writing his autobiography with Mary Alinder, who is employed as his executive assistant. John Sexton becomes photographic assistant through 1982.

1980
Receives the Presidential Medal of Freedom, the nation's highest civilian honor, from President Carter. Receives the first Ansel Adams Award for Conservation given by The Wilderness Society. Publishes The New Ansel Adams Photography Series Book 1, *The Camera* (NYGS). Exhibition *Ansel Adams: Photographs of the American West* organized by The Friends for the USICA and circulated through 1983 in India, the Middle East and Africa.

1981
Receives honorary Doctor of Fine Arts degree from Harvard University. King Carl XVI Gustaf of Sweden presents him with second Hasselblad Gold Medal Award. Named Honored Photographer at the national meeting of the Society for Photographic Education. Holds final workshop in Yosemite, then transfers workshop location to the Carmel area under the administration of The Friends of Photography. Publishes Book 2 in his revised technical series, *The Negative*

(NYGS). Hour-long biographical film *Ansel Adams: Photographer*, co-produced by Andrea Gray and John Huszar for FilmAmerica. Mural-size print of *Moonrise, Hernandez, New Mexico*, is sold for $71,500, the highest price ever paid for a photograph.

1982
Celebrates eightieth birthday with a black-tie dinner sponsored by The Friends of Photography for over 200 guests, during which he is presented the Decoration of "Commandeur" in the Order of the Arts and Letters, the highest cultural award given by the French Government to a foreigner. Two exhibitions, *The Unknown Ansel Adams* and *The Eightieth Birthday Retrospective* honor the event at The Friends Gallery and the Monterey Museum of Art, respectively. Pianist Vladimir Ashkenazy plays a birthday concert for him in his Carmel Highlands home. Receives honorary Doctor of Fine Arts degree from Mills College. His 1936 Stieglitz gallery exhibition is recreated and circulated by the Center for Creative Photography as *Ansel Adams at An American Place*. Publishes three large posters, the first of a series (NYGS). Chris Rainier becomes photographic assistant.

1983
Publishes *Examples, The Making of 40 Photographs;* Book 3 of the technical series, *The Print*, three posters and a 1984 calendar (all NYGS). Subject of an extensive interview in *Playboy* magazine. Meets with President Reagan on environmental concerns. Elected as an honorary member in the American Academy and Institute of Arts and Letters. *Exhibition Ansel Adams: Photographer* is organized by The Friends of Photography as a cultural exchange between the sister cities of San Francisco and Shanghai, China. Exhibition also travels to Beijing, Hong Kong and Tokyo. Ansel Adams Day proclaimed by the California State Legislature.

1984
Dies April 22 of heart failure. Major stories appear on all major television networks and on the front page of most newspapers nationwide. A commemorative exhibition and memorial celebration are held in Carmel's Sunset Cultural Center. California Senators Cranston and Wilson sponsor legislation to create an Ansel Adams Wilderness Area of more than one hundred thousand acres between the Yosemite National Park and the John Muir Wilderness Areas. Unanimously elected as an honoree of the Photography Hall of Fame.

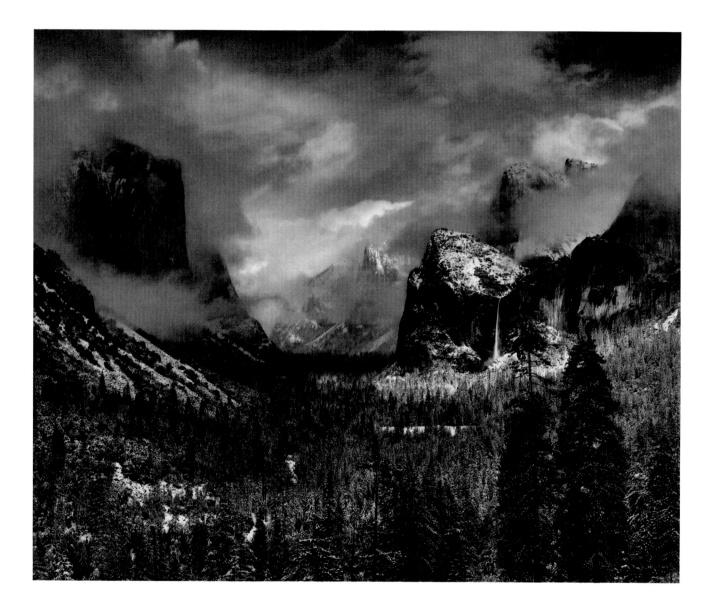

ANSEL'S LAST DAY
by Mary Alinder

Ansel's death has been very difficult for everyone, but in a strange way it has been easier for the few of us who were near him in his last hours, because we had the luxury of being with him and saying goodbye. I began working for Ansel as his executive assistant in 1979. My responsibilities included supervising the staff and his many projects, but my most important job was assisting Ansel as he wrote his autobiography. Besides having a degree in English, I am also a registered nurse—a combination that proved valuable in my work with Ansel. I'd like to share with you what April 22, the day Ansel died, was like.

On Friday morning, April 20, Ansel experienced increased chest tightness and shortness of breath. Since he had a history of heart problems we went to the Community Hospital of the Monterey Peninsula, where he was admitted for tests and observation. Ansel had been in and out of that hospital quite a bit during the past few years, but work always continued; we had established a regular office routine. Our joke was that this was the one time I could get him to really concentrate on things since he was confined to his bed. We accomplished alot working together writing and rewriting chapters of his autobiography. The photographic assistants would come with prints and negatives for him to look at; Virginia would always come with the mail—his favorite time of the day—and Fumiye, their cook, would bring sushi. The routine was the same that Friday when Ansel went to the hospital. This was just going to be one more brief stay there.

Ansel progressed well on Saturday, and on Sunday when I arrived with the morning papers we sat and chatted, read the papers together and hooted over the headlines. That Easter Sunday, April 22, had been planned for the whole year to be very special. The great pianist Vladimir Ashkenazy had become a good friend, and he had agreed to come and give a small, private concert in Ansel and Virginia's home that day. We thought until the last minute that he might be able to attend the concert, but it turned out not to be possible. Ansel was having greater difficulty in breathing, and the decision was made to move him into intensive care.

When Ashkenazy arrived at Virginia and Ansel's on Sunday morning to practice, he was told that Ansel would not be able to be there. Ashkenazy was disconsolate. He had come to perform for Ansel—for his family and friends, too—but really for Ansel. Ansel called him from the hospital and said, "Ashkenazy, please do it, you

CLEARING WINTER STORM, YOSEMITE NATIONAL PARK, CALIFORNIA, 1944.

must play." He added, with a laugh in his voice, "The show must go on! I'll see you afterward." Ashkenazy did perform, and it was beautiful. We enjoyed his playing of Schubert, Schuman and Chopin, and I think we all felt that Ansel was listening with us the whole time.

I had been at the hospital all morning, and Ansel insisted that I attend the concert. He was being cared for by Dr. Thomas Kehl, who has been superb during Ansel's last few years of fragile health. His partner, Dr. John Morrison, was on duty, and he said he would stay with Ansel while I went to the concert. Ansel said, "Go, then come and tell me about it." Besides, he was reading a great detective mystery, and had not figured out yet who had done it. I think he thought if he got rid of me he would have time to find out.

After the performance I took Ashkenazy and his wife Dodie back to the hospital to see Ansel. I had warned them that he was in intensive care, and that he was fine but was quite weak. But when they walked in, Ansel sat up, stretched out his arms in welcome and said, "Ashkenazy! So great of you to come." He was his usual, strong self. He was so vital, it was hard to believe that he could be so seriously ill. They had a won-

derful time together.

Then Ansel's good friends Otto and Sue Meyer came. They were with him a few minutes, and he had a little bit of dinner. Virginia arrived with their family: Michael and Jeanne Adams with Sarah and Matthew; and Anne and Ken Helms with Allison, Ginny and Katherine. The whole family was around him, and he was in great spirits, drawing so much energy from the family. As I was leaving for dinner at home, he said, "Goodbye Dahlink," in the Russian accent he liked to use. I told him I would return later to tuck him in.

About 9:30, just as I was about to go back to the hospital, Dr. Morrison called saying that Ansel was having some problems. I live quite close to the hospital and was out the door in a flash. When I arrived, Ansel's bed was completely surrounded by Dr. Morrison, the nurses and alot of equipment, but I was able to make my way to Ansel. He had an oxygen mask on, but he was responsive and was not in pain. I put my arms around him, put my cheek next to his and I talked to him about what was going on, telling him that everything was going to be all right. He squeezed my hand and tried to talk, but it's difficult to do so while wearing an oxygen mask.

The medical staff and I

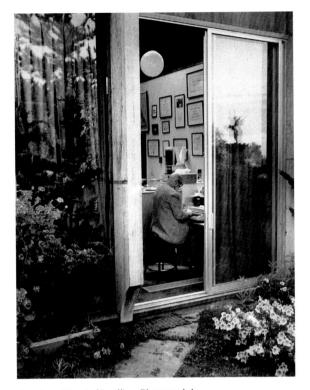

Ansel working in his office. Photograph by Angus McDougall.

stepped out for awhile when Virginia arrived so they could be together; I came back a few minutes later. Ansel just slowly passed away; he quietly stopped breathing. It was extremely peaceful. We were very happy that he could die with such comfort, without suffering, because the one thing Ansel would never accept was to be anything less than himself in mind and body. And he maintained that style, vigor and purpose right to the end.

I want to close with some of Ansel's words. This letter is a favorite of mine, and a favorite of Ansel's. He wrote it in the late 1930s to Cedric Wright, who was a very close friend, a violinist, a photographer and a Sierra Clubber.

Dear Cedric,

A strange thing happened to me today. I saw a big thundercloud move down over Half Dome, and it was so big and clear and brilliant that it made me see many things that were drifting around inside me; things that related to those who are loved and those who are real friends.

For the first time I know what love is, what friends are, and what art should be.

Love is a seeking for a way of life; the way that cannot be followed alone; the resonance of all spiritual and physical things. Children are not only of flesh and blood. Children may be ideas, thoughts, emotions. The person of the one who is loved is a form composed of a myriad mirrors reflecting and illuminating the powers and thoughts and the emotions that are within you—and flashing another kind of life from within.

Friendship is another form of love—more passive perhaps—but full of the transmitting and acceptances of things like thunderclouds and grass and the clean reality of granite.

Art is both love and friendship; it is the desire to give. It is not charity, which is the giving of things; it is more than kindness, which is the giving of self. It is both the taking and giving of beauty, the turning out to the light the inner folds of the awareness of spirit. It is the recreation on another plane of the realities of this world; the tragic and wonderful realities of earth and man.

Ansel

MARY ALINDER is the executive director of the Ansel Adams Publishing Rights Trust and the editor of Adams' autobiography. She began working with the photographer in 1979 as his executive assistant.

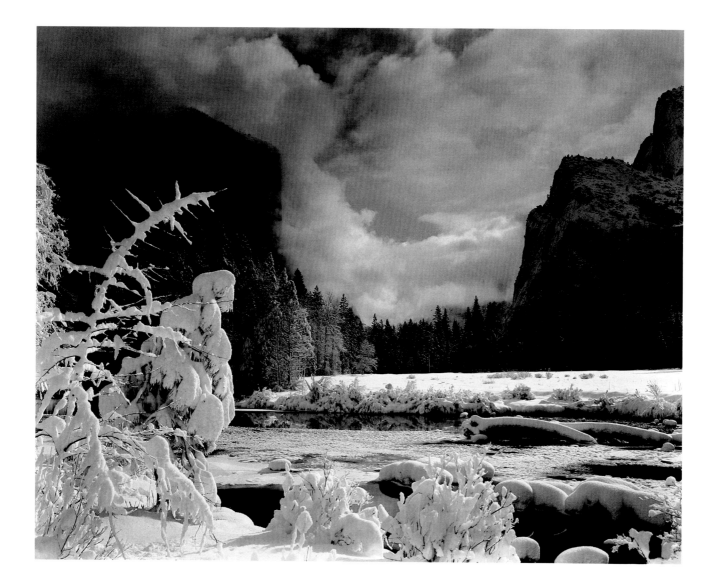

THE MAN OF MANY FACETS
by Alfred Glass

Ansel came into my life in December of 1944, during World War II. At that time, the Awahnee Hotel in Yosemite Valley was a naval convalescence hospital. I arrived as a resident minister that month, and I was asked to conduct the Christmas Eve service in the chapel of the hospital. As I planned the service, I realized I needed an organist. Someone said, "Ansel Adams plays the piano." In my naive way, I went over to Best's Studio and I asked Ansel if he would play the organ. That Christmas of 1944, Ansel played beautifully on an old reed organ in a way that spoke to all our hearts.

This is a man of many, many facets. I always liked his common touch. Two years ago I attended that beautiful celebration for his eightieth birthday, which was a wondrous expression of love and affection, not only for a great professional but for a real human being. As my wife Helen and I were waiting in line outside the exhibition in The Friends of Photography Gallery, Ansel came out the door. Amidst all the people, and with all goings on, he spotted me and, with laughter in his voice, said, "Do you remember when you caught me in a bar in Saratoga?" This was the Ansel who lived among us and richly shared in every way his life and talents.

Today we are honoring him, celebrating him, because one cannot do otherwise with such a life. As I have listened to these tributes and to the richness that has been revealed, I wonder how we could retain his memory in a vivid way. May I make a few suggestions?

I am sure he is going to live through his family—Michael and his family; Anne and her family; and, supremely, through that gallant lady, Virginia. She resolutely set herself to be in the background of his life, and created an atmosphere of tranquility, peace and love in which Ansel could develop and exercise his creativity. His memory will really live on in those lives, and through them to us.

Ansel will also live on in our memories, in the glory and beauty of his photographs. We have heard today that in these photographs, Ansel placed his technical skills, his creative composition and also his feelings and his spirit. The very essence of Ansel is in every photograph he made. We can keep his memory alive in our hearts if we approach even his familiar photographs with the imaginative richness of our minds, as well as with an intellectual appreciation. In the modern parlance of our day, we can see and feel his photographs with both hemispheres of our brain. If we do this, Ansel and all the richness of his

GATES OF THE VALLEY, YOSEMITE NATIONAL PARK, CALIFORNIA, 1938.

life will be shared with us again and again. He will live in us in a way we will never forget.

Ansel will also live on because of his love of God's world, the natural world. No man was more at home in his universe than Ansel. Few men pierced the heart of the universe as Ansel did. Few men found the hidden beauty that we might miss, and gave that beauty to us as Ansel did. Few men stood up to battle for the welfare of the environment as Ansel did. How can we ever forget his rich insights, his courage and his commitment to the "good earth?" Yet Ansel leaves an unfinished task to which he gave all the power and creativity of his life. That task, now, more than ever, becomes our responsibility.

But we cannot talk of Ansel only in memory. The quality of his life was so much a part of the earth, lived in and for the earth, that it cannot die. The spirit, the vitality, the humor, the adventure, the creative richness and the love of Ansel Adams is living in our universe today. And if we are sensitive enough and open enough, he will walk in comradeship with us.

"MONOLITH, THE FACE OF ANSEL ADAMS, YOSEMITE NAT'L PARK"

Paul Conrad. ©1984, Los Angeles Times. Reprinted with permission.

REVEREND ALFRED GLASS is the former pastor of the Yosemite National Park church in Yosemite Valley, where he served from 1944 until 1958. He is currently a marriage and family counselor.

A SENSE OF TONE
by Rosario Mazzeo

Ansel was Ansel. His very name bespeaks the highest standards. It is difficult to imagine anyone even remotely like him. He was at once a pixie, a studious gentleman, an imp, an extraordinarily talented musician—certain elements of his piano playing compared amazingly well with the finest of our artist performers—a host par excellence, a genius more cheering than a campfire on a rainy night, an enthusiastic story teller (often with theatrical gusto), genial—sufficiently so as to be a shining example of the meaning of the word, a loud debater ... and one of my closest friends.

I have known Ansel since the early 1950s. During the first years of our friendship he came often to visit us in our home in Boston. We had wonderful evenings of talk, dining, music, jokes (not all were printable) and general camaraderie that ran the gamut from softest to loudest.

During those years, my wife Katie Clare acquired a beautiful Boesendorfer grand piano, and we had our first professional tape recorder. During the "Ansel" evenings we used to turn it on to catch whatever sounds came its way throughout the several hours. Ansel had fallen in love with the Boesendorfer and would descend upon it at once when he arrived, as well as between dinner courses and afterward. Obviously he had not kept up the digital technique required for extended playing; the performances were sporadic, but blessed with extraordinary tone quality and beautiful phrasing. Indeed, when occasionally we played these tapes for some of the musical dignitaries who used to come to our home, they would listen quizzically, then guess that it might be "—Rubinstein?—or maybe Gieseking?—or—?" This same sense of tone and musical delivery was fully carried over to his images. In combining the science and art of photography, he was to carry the torch far beyond anyone else in his time or before.

In the early years of our acquaintance I came west for a month or so each summer, and we had wonderful photographic trips, sometimes accompanied by Cedric Wright. We ranged all about in the Big Sur-Carmel area, and in Napa, Sonoma and Yosemite. Invariably we talked continually from awakening until the last sleepy "good night." I remember one field trip up into the wine country. Ansel was doing a book for the American Trust Company—now Wells Fargo— and wanted an expansive view of a vineyard, having an idealized one in mind. We went here, and we went there. At the third or fourth field I said,

noting the sameness of terrain, sun position, etc., "Look here Sunny Buoy, we are going to be in trouble." (Incidentally, I must explain my nickname for him—"Sunny", because he was always cheerful—"Buoy", because you could tie your photographic boat to him. If the question was photographic, he had the answer. If it were other, he could figure it out.) "These vineyards all look alike. They are on western-facing hillsides. The sun is in the same relative position, and the general configurations are too similar." "I've been thinking about that," he said, "and I've got it all figured out. From now on the first thing we do will be to go to the tasting rooms. What they serve us will provide the necessary cross-references."

For many years, beginning in 1966, I have had the privilege of living as a neighbor to the Adamses. There was scarcely ever a day when we did not communicate—at a meal, or by letter, a note, or a least a phone call, whatever the hour. Always a joke or two, some piquant tidbit of news, often a debate that we could complete only by coming to one or the other of our houses. Ansel was inordinately kind. I remember one morning, in the first days of struggling with my then-new electronic marvel of an IBM typewriter. Having problems with the cancelling ribbon

installation, I phoned Ansel, who had been through the same thing with his IBM. Though it was mid-morning, and he was in the midst of printing, he said, "Just a minute, until I take this print out of the hypo." He did not phone. He appeared at the door.

As we are all aware, he was a man of so many facets as to be confusing to most of us. But his prime loves were the "ultimate fact" (no detail was too small to pursue), the out-of-doors, conservation of our lands, the true fusion of the art and craft of photography and, *always*, music and conviviality. He was a born entertainer. As we became closer friends, we agreed on just about everything ninety-nine percent of the time. The other one percent? We disagreed emphatically, though we had the same objectives.

Hearing so many statements of praise and adulation on all sides, including those from the various speakers on the program, and knowing of the extraordinary regard for Ansel which is continually evidenced everywhere, makes it necessary for me to put forth a few words of caution. We must be careful, or we will find that the next step is to elevate Ansel to Sainthood. This would never do. It presents all kinds of problems.

For instance, it is wonder-

ful to have a Mt. Ansel Adams in Yosemite, indeed it is called for. But we must not have a Mt. Saint Ansel Adams. Not only might the U.S. Supreme Court get into the act, since it could involve the old problem of separation of church and state, but it would deprive Ansel of certain of his best stories—the unprintable ones. He would have to wear a halo, and you know he really preferred a Stetson. Besides, who ever heard of a saint wearing a Stetson? So let us be kind, and treat him as the incredible person he was.

He has, in fact, left an indelible stamp on all our lives.

ROSARIO MAZZEO, teacher, author and a master of the clarinet who formerly played with the Boston Symphony Orchestera, was one of the founders of The Friends of Photography.

SAND DUNES, SUNRISE, DEATH VALLEY NATIONAL MONUMENT, CALIFORNIA, 1948.

A LEGACY OF ART AND ACTION
by Alan Cranston

Some years back Ansel Adams was being interviewed by a correspondent who insistently referred to him as Mr. Adams. Ansel would have none of it. "Please don't call me Mr. Adams," he said. "It makes me feel old, and I don't."

I liked that about Ansel—his resolute refusal to give in to the mythology of age. The only thing he liked about growing old was free admission to National Parks. He was forever one of the youngest people I have ever met; his enthusiasm for life was contagious. Life was a glorious adventure to be lived to the hilt. Life was friends to talk with, students to teach, art to be created, causes to be fought and laughter to be shared.

When death came at eighty-two, Ansel Adams had lived a life that was both complete and passionate. He left a legacy of art and activism, and he left legions of friends and acquaintances whose own lives were forever changed by having known this great and gentle man.

Today we celebrate that grand, eloquent life that so enriched us all. We do so in this magical setting on the Monterey Peninsula, surrounded by the landscape Ansel Adams loved. Here, along with his beloved Yosemite, is where he drew his strength, his vision, his passion and his dreams. Ansel above all else was a passionate man. He sensed more clearly than most that the great work of the world is done by those with a fire in their belly and a vision in their heart.

I did not meet Ansel until 1980, when he worked on legislation to protect Big Sur—a task we shall fulfill. I had admired his work for many years. We sat together at Point Lobos one day, looking out at the ocean and watching the sea otters play in the surf. We talked about the critical environmental issues of our time—the future of land, sea and air, and the survival of all who inhabit this glorious planet.

Ansel was an ardent conservationist for more than sixty years. He was the most forceful spokesman for preservation of the natural environment I have ever met, and his life was fueled with new challenges every day—fighting for the Big Sur that we knew and loved, working to rid the Interior Department of James Watt.

The Ansel Adams I came to know was the quintessential man of the rugged West. He loved to dress the part—Stetson, string tie and all. I am convinced the word "grizzled" was coined to describe Ansel's beard. I felt especially close to him, of course, because of his bald head. Colorful and dedicated, he was that rare combina-

STREAM, SEA, CLOUDS, RODEO LAGOON, CALIFORNIA, 1962. (POLAROID NEGATIVE).

tion of passion and persistance. He did not just talk with politicians, he worked us over; and his enthusiasm overwhelmed us. His photographs of Kings Canyon so impressed Franklin D. Roosevelt that the President became a vigorous advocate of what became the Kings Canyon National Park, which Ansel considered, quite legitimately, his personal monument.

For over half a century Ansel traveled to every part of America. He photographed the extraordinary beauty of our land from Alaska to the Appalachians, from the Maine coast to Yosemite. And he photographed our people. His photographic record of the internship of Japanese-Americans in California during World War II, called *Born Free and Equal*, is an eloquent visual telling of an issue in which I have long been involved.

Ansel will be remembered not just for his art, but for his life. There was little difference in how he approached each. He planned what he could, but his spontaneity was boundless. He started out as a concert pianist, and ended up the greatest photographer of the American West that ever lived. "A photograph," Ansel once wrote, "is not an accident, it is a concept." He characterized his aims in art as "seeking spiritual resonance as moving and profound as great music." "A great photo-

graph," he said, "is a full expression of what one feels about what is being photographed in the deepest sense, and is, thereby, a true expression of what one feels about life in its entirety."

Ansel saw the West not only with his eyes and his camera, but with his soul. In the mountains, rivers and valleys of the West he saw poetry, he saw truth, he saw wisdom, he saw grace. To Ansel, the terrain so gorgeously caught by his lens was not just earth and sky, but spirit and vision. His concern for preservation of America's wilderness mirrored his deep belief that we treat our physical setting not much differently from how we treat our human family as a whole.

Throughout his life and career, Ansel Adams was both artist and warrior. He excelled at both. He did more than chronicle places and people, he worked to enrich them. The life and work of Ansel Adams was a tapestry of beauty, of truth, of vision and of justice. He had a sense of integrity of all things that fired him with its urgency. He carried within him that rare and holy sense that shines through the lives of all great people—that sense of being part of something larger than oneself, that keen excitement of knowing you are the right person, in the right place and time, doing the right work.

The centerpiece of Ansel's life was his friendship—his love—for this planet. That is how our planet and its people will remember him—through photographs that will endure forever depicting the America of our time, for all time.

ALAN CRANSTON, a strong advocate of legislation protecting the environment, is the senior United States Senator from California.

Photograph by Gerry Sharpe.

THE ENVIRONMENTAL ADVOCATE
by William A. Turnage

My association with Ansel began when he was nearly seventy, a time when most men would have been playing golf and taking Caribbean cruises. Not Ansel! He was *never* going to slow down, never cease his life's work. And as we all witnessed, how wonderful and rewarding—for us and for him—were his years as, if I may use the phrase, a "Senior Citizen!" Ansel's attitude was simple. "If you have to get old, you may as well get as old as you can!"

What shall I say of this legendary man . . . this giant of humanity . . . this champion of the common weal? The newspapers said Ansel was "America's most influential environmentalist." Indeed he was—and more—for truly Ansel was the John Muir of our century. Presidents were eager to meet with him; members of Congress respected him and rejoiced in his friendship; environmentalists revered him.

Ansel was deeply gratified when our nation's highest civilian award, The Presidential Medal of Freedom, was conferred upon him by President Carter, at the urging of President Ford. The citation, read by the President, says it best:

At one with the power of the American landscape, and renowned for the patient skill and timeless beauty of his work, photographer Ansel Adams has been visionary in his efforts to preserve this country's wild and scenic areas, both on film and on earth. Drawn to the beauty of nature's monuments, he is regarded by environmentalists as a national institution. It is through his foresight and fortitude that so much of America has been saved for future Americans.

Ansel's environmental accomplishments were many, and many will truly last forever. But one great cause, his last cause, remains unfinished— Federal protection for the Big Sur coast, that heroic gesture of earth and ocean he loved so tenderly. Ansel, in his last days, asked for only one promise from me: that the work to save Big Sur would never cease until the job was done. I gave him my promise.

The Wilderness Society was founded fifty years ago. It took us more than twenty years to pass The Wilderness Act of 1964. It took us more than ten years to pass The Alaska Lands Act of 1980. In good time—with a Senate once again chaired by those who truly care for our environment; with the courageous and skilled leadership of Alan Cranston, with Sala Burton carrying on in Phil's tradition, with Ansel's special friends, John Seiberling and

Mo Udall pressing forward, all will come right. We will finish the job!

Ansel's credo, in the great Western tradition of service to his fellow citizens, was "pass it on." And now he has passed on the responsibility to save Big Sur to all of us who loved him so, to all of us gathered here today.

One of Ansel's greatest legacies is the sense of hope and commitment he passed on to young Americans, to the environmental leaders of the future. I have received a great many letters in the few weeks since Ansel died, but one which arrived only yesterday, from a young and very able member of my staff, the director of our office in Idaho, expresses this legacy in a lovely way. I would like to share part of the letter with you:

Ansel was truly the greatest individual I have ever met. He has been an inspiration to me ever since I met him six years ago. His character was as great as his accomplishments.

Losing Ansel only makes us want to fight harder to

preserve what he cared most about. I only wish he could be around to witness the accomplishments that we will no doubt achieve in the coming years. Eventually, too, Bill, we will ensure for all time the protection of his beloved Big Sur coast.

In the end, though, I cannot describe Ansel's greatness, or even hint at the gentle, joyful incandescence of that truly luminous personality. Only the poets and the gods will ever be able to describe Ansel.

Allow me, then, to leave you with some words you no doubt know well, but which so beautifully speak of the great gusto and passion with which Ansel faced the last decade of his long and wonderful life, from *Ulysses*, by Alfred, Lord Tennyson.

—you and I are old;
Old age hath yet his honour and his toil;
Death closes all: but something ere the end,
Some work of noble note, may yet be done,
Not unbecoming men that strove with Gods.
The lights begin to twinkle from the rocks:
The long day wanes: the slow moon climbs: the deep
Moans round with many voices. Come, my friends,

'Tis not too late to seek a newer world.
Push off, and sitting well in order smite
The sounding furrows; for my purpose holds
To sail beyond the sunset, and the baths
Of all the western stars, until I die.
It may be that the gulfs will wash us down:
It may be that we shall touch the Happy Isles,
And see the great Achilles, whom we knew.
Tho' much is taken, much abides; and tho'
We are not now that strength which in old days
Moved earth and heaven; that which we are, we are
One equal temper of heroic hearts,
Made weak by time and fate, but strong in will
To strive, to seek, to find, and not to yield.

WILLIAM A. TURNAGE, currently executive director of The Wilderness Society in Washington, D. C., previously served as Ansel Adams' business manager.

MIRACULOUS INSTANTS OF LIGHT
by Wallace Stegner

It would be presumptuous, and out of tune with this occasion, to attempt a definition of Ansel, or an assessment of his place in art, or anything so solemn. It would be equally out of tune to eulogize him. I only want to celebrate him—what he meant to me, how he affected my thinking and my conduct and especially my spirits.

He enlarged and enhanced life, and he was all of a piece. In his person, in his art, in his reverence for nature and his affection for people, in his long and often headlong advocacy of honorable causes, in his hatred of crookedness, deviousness, dishonesty and irresponsibility, and in his steadfast belief in the human potential for dignity and even nobility, he forced us upward, never downward.

He woke up dead rooms, he lifted slow pulses, he stiffened sagging spines. Full of laughter and high spirits, in love with word-play and the play of ideas, he never telephoned without a new joke, and rarely wrote so much as a postcard without a jingle or limerick to lighten it. That joviality covered, but could not mask, the solidity and strength of real principles and immovable integrity. A rock is not less granite because sunlight plays across it.

There is a story, known I am sure to many, that the painter John Marin, while staying at Mabel Dodge Luhan's house in Taos, was offended one afternoon by a bunch of people coming in from outdoors, laughing, talking, loud—*stamping,* as Marin said with distaste. While they flooded the room with noise and Marin looked for an exit, one of them went across to the piano and with his forefinger struck one note. *One note,* Marin said. The noise dropped, faces turned, the room filled with expectation, charmed by the touch that had evoked that sound. The touch was of course Ansel's. In music or in his lifetime pursuit of miraculous instants of light, as well as in his relationships with his family and his thousand friends, he had that gift, and never lost it. He did enhance and enlarge life. No moment was safe from him.

Yet no artist was ever less self-assertive or auto-bio-magniloquent. "Man, in the contemplation of nature, need not contemplate his external self," he said. Still, what he denied access as a subject for photography could not be excluded from his art. Ansel's art was too quintessential an expression of himself, his feelings, his deepest beliefs, for that. He did not merely *record* the great images of nature that made him famous around the world; he first envisioned them, invented them, created them, and *then*

he clicked the shutter. Those images do not exist in nature, they were born in his vision of them. The artist is inseparable from his art. He is immanent in every picture.

Ansel shared with Alfred Stieglitz the faith that art should be evidence of a "spiritual identification with the world" and an "enhancement of life." It is said, and I believe it, that *Portfolio One* was a photographic tribute to Stieglitz, that every image in it is in some way Stieglitz himself—mountain, roadside delicacy of ferns, solitary saguaro, oak tree under snow. From Stieglitz, Ansel borrowed the term "equivalent" for what a finished print actually revealed: it was the external world as shaped by the photographer's perceptiveness, imagination and emotional response, the equivalent of what he felt at the moment of creation.

Praise be, he left us hundreds of such equivalents. They contain his spirit as surely as they contain El Capitan or Hernandez, New Mexico, or Banner Peak in storm. They even contain his causes. I think it would be hard to be a land butcher with one of Ansel's images on your office wall.

Ansel's mind and vision, his reverence, his delicacy and strength, his granite and the sunlight that played on it and the grave shadows it sheltered will have power to move and enhance and enlarge us as long as walls exist for photographs to hang on and the culture retains the skill to print from negatives. He has left us both scores and performances, and therefore himself. He is not a man to be merely remembered. He is here. We have him.

WALLACE STEGNER is a Pulitzer Prize winning writer and former professor of English at Stanford University. Author of many books, his most recent is Big Rock Candy Mountain (1983).

Ansel Adams, February 1984. Photograph by Jim Alinder.

AN ASCENDANT VISION
by Peter C. Bunnell

How did one come to know personally a man like Ansel Adams? In my own case, I corresponded with him before I made his acquaintance. This correspondence began nearly thirty years ago, when I was a student. Looking through it this week I noticed that I addressed him then as "Dear Mr. Adams." From the first he addressed me as Peter. It seems so formal, especially now that he is gone, to think that Ansel could have ever been Mr. Adams to anyone, so munificent was his manner. Soon I was addressing him as Ansel; I do not remember if it was at his request, because there had also been an escalation in our relationship—we had met. This was in Rochester, New York, where I had been invited to a garden party by Beaumont Newhall, his wife Nancy and Minor White, to meet their colleague from California. My correspondence with Ansel continued down to this year. We saw each other frequently, especially during the last fifteen years, since we both were involved with The Friends of Photography. It is as president of the Board of Trustees of this organization that I offer our respects to the memory of this man. I am honored to say he was also my friend.

How might we characterize the artist and the man? Ansel was passionately in love with passion, and coldly determined to seek the means of expressing it in the most visible way. An immense passion, reinforced with a formidable will—such was the man. In this duality we find the two signs that mark the most substantial geniuses.

It is evident that for Ansel the imagination was the most precious gift, the most important faculty, but that this faculty remained impotent and sterile if it was not served by a resourceful skill which could follow it in its restless and imperious ways. He certainly had no need to stir the fire of his always incandescent imagination, but the day was never long enough for his study of the material means of expression. It is this never-ceasing preoccupation that seems to explain his endless investigations into technique and the quality of photographic representation, his lively interest in matters of chemistry and physics and his work with the manufacturers of photographic materials. In this respect he comes close to Leonardo da Vinci, who was no less possessed by the same obsessions and who sought to see everything without shadow.

Ansel was a curious mixture of skepticism, politeness, dandyism, burning determination, craftiness, despotism and, finally, of a sort of personal kindness and tempered warmth that always accompanies ex-

traordinary capacity. There was much of the romantic in him. This was in fact the most precious part of his soul, the part that was entirely dedicated to the photographing of his dreams and to the worship of his art. There was also much of a man of the world; that part was destined to disguise the other. It was, I think, one of the great concerns of his life to conceal the rages of his heart and not to force his larger-than-life demeanor. His spirit of dominance, which was quite legitimate and even a part of his destiny, sometimes almost entirely disappeared beneath a thousand kindnesses. He owed to himself, that is to say to his genius and the consciousness of his genius, a sureness, a marvelous ease of manner, combined with a politeness which, like a prism, admitted every nuance, from the most cordial good nature to the most irresponsible crudeness or inanity. He was all energy, energy that sprang from the nerves and from the will.

The morality of his works— if it is permissible to speak of ethics in photography—is visibly marked with the understanding of the heroic in our lives, of the choices we must make between right and wrong, of our searching out of the reasons for life itself. He occasionally found it possible to concentrate his camera on the expression of tender and voluptuous feelings, for certainly he was not lacking in tenderness; but even into these images, as in all of his works, he infused an incurable rightness in strong measure. Carelessness and whimsy—the usual companions of simple pleasure—were absent from them.

Ansel's legacy will, of course, be his incomparable photographs—both as a demonstration of his brilliant technique, which has so fundamentally altered our conception of photographic picture making in the twentieth century, and also because of their style and content. They tell us not only of his concern for our land but of his concern for everything about us. They are timeless and expressive with the haunting quality of the deeply felt. Today we surely sense that it is the end of an era, of a career concluded, but I do not believe that this is the way he would wish us to think. He was too positive and too forward-looking.

If you consider his most famous photograph—*Moonrise, Hernandez, New Mexico*—you realize after a moment of thought that this is really a sunset picture. The moon is reflecting received light, the light striking the adobe church and the crosses in the cemetery is from the sun. Crop away the top portion of the picture and

MOONRISE, HERNANDEZ, NEW MEXICO, 1941.

there is no ambiguity; it is a heliograph pretending to be a lunagraph.[1] This special achievement in pictorial virtuosity is, I believe, emblematic of Ansel's essential ideology. The factuality and, moreover, the meaning of the setting sun were rejected by him in favor of the expressive symbolism of the rising moon; of the shining luminescence ablaze with greatness in its primal mystery, dramatically isolated in the infinity of darkness. Like all poets, he transported us into a world that is vaster and more beautiful than our own, where reality echoed the dream.

So I would rather think of Ansel's legacy as ascendant, and think of him in the continuousness of the work that is The Friends of Photography. It is the organization he helped found seventeen years ago, and which he guided with his personal philosophy and through his benefaction until his death. In his spirit we will continue to support the medium he loved so dearly. The title of our organization is characteristic of the intelligence in Ansel. In his youth, in 1932, he eagerly aligned himself with the audacious notion that Group f/64 represented—that there was an orthodoxy to photography—but with maturity, a graciousness ripened and a certain pluralism triumphed in his understanding, so that in

Adams with a straight print made for teaching purposes and a finished print of Moonrise. *Photograph by Jim Alinder.*

his naming of The Friends we have an expression of community, of originality and diversity. We shall miss him, but we will cherish him; we will know always that he is with us in our labors, for surely he would have agreed with Henry James who, at the end of his life, wrote, "It is art that makes life, makes interest, makes importance . . . "

NOTE

1. This interpretation was first articulated by Mike Weaver. See "Ansel Adams: Inter-State Luminist", in *Creative Camera* 138 (December, 1975).

PETER C. BUNNELL is the David H. McAlpin Professor of the History of Photography and Modern Art at Princeton University and the president of The Friends of Photography.